BARBADOS:

A Souvenir in pictures

Barbados is pear-shaped, only 21 miles long and 14 miles wide and is the most easterly island of the Antilles chain. The island's name originates from the Portuguese who christened it Los Barbados, the bearded ones, after the beard-like fig trees which grew there at the time. The first English settlers landed on the island in 1627 and the first Parliament was established in 1639. Barbados remained British until 1966 when it became an independent nation within the Commonwealth. The climate is one of the healthiest in the world, with warm sunshine for most days of the year and cooling trade breezes. The varied coastline includes miles of spectacular beaches washed by warm turquoise tropical waters. Inland, narrow roads twist through green sugar-cane and in the eastern area rolling hills provide splendid views across the island to the coast. Barbados retains an old world charm, in atmosphere, its traditions, historic reminders and the friendliness of the people, known either as Bajans or Barbadians. All these factors combine to make Barbados the perfect place to laze and relax. This book illustrates a selection of the many attractions Barbados has to offer. It is produced with the hope that visitors will discover and experience these for themselves. It will also be a souvenir of an unforgettable visit and a reminder to return quickly to the 'island in the sun'.

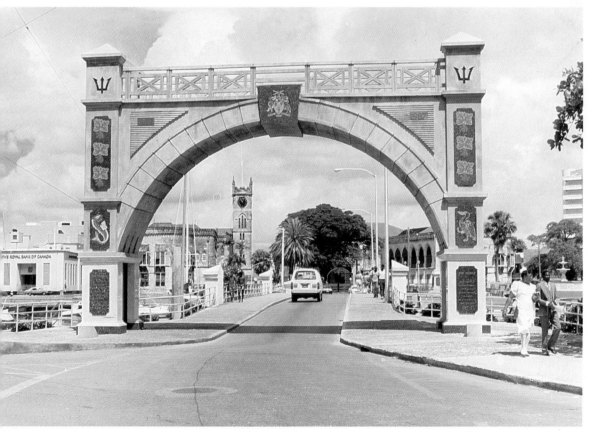

The Arch, at the end of the bridge, erected in 1987 to commemorate the 21st anniversary of Independence. *(G.W. Lennox)*

1

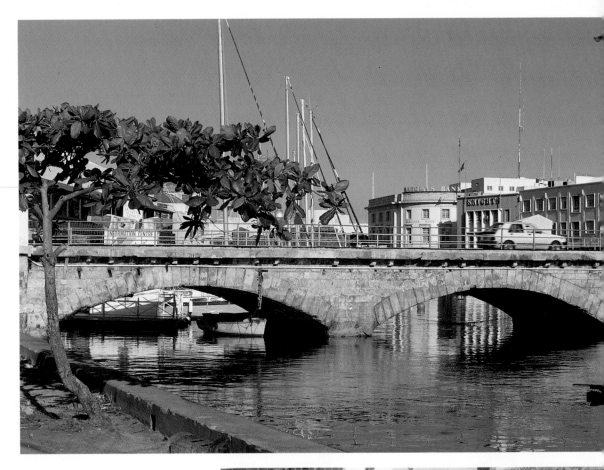

Bridgetown

The bridge which separates
the outer basin of the
Careenage from the inner.
(G.W. Lennox)

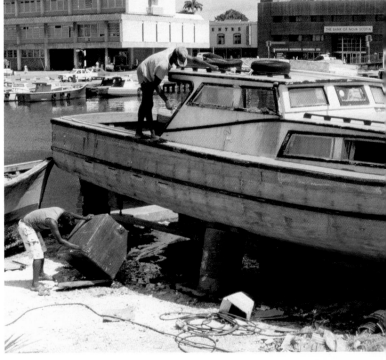

The Careenage where at one
time vessels had their bottoms
scraped and cleaned. This
occasionally happens today as
the photograph shows.
(G.W. Lennox)

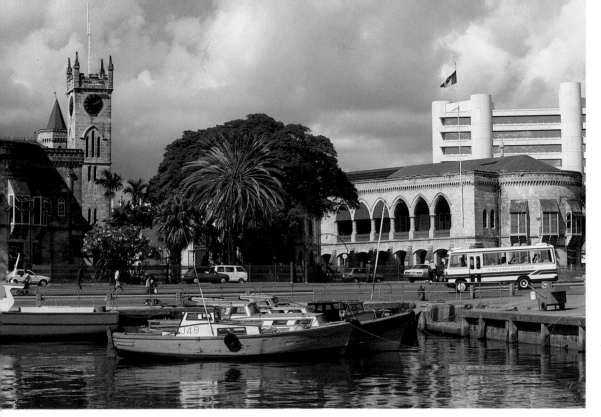

House of Assembly; in the background is the modern Central Bank. *(G.W. Lennox)*

The fountain in the centre of Bridgetown, erected in 1865 to commemorate the introduction of piped water to the city. *(G.W. Lennox)*

Nelson's Column in Trafalgar Square. *(G.W. Lennox)*

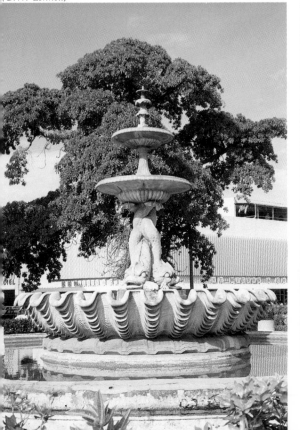

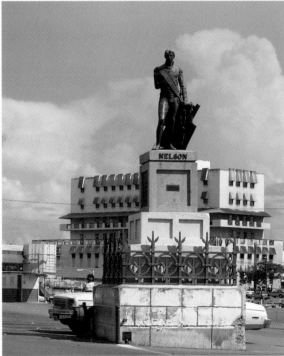

3

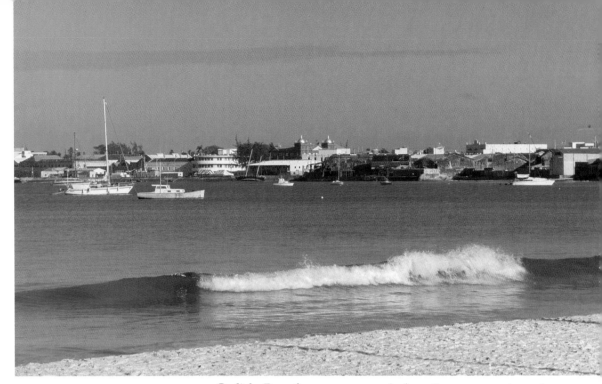

Bridgetown Outskirts

Carlisle Bay, for many years before the construction of a modern harbour, a port of call for ships from all over the world There is a fine view across to Bridgetown from the bay.
(G.W. Lennox)

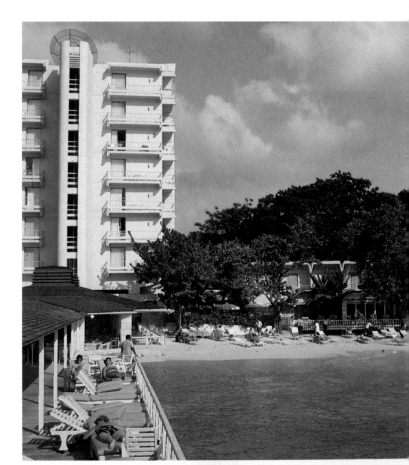

The Grand Barbados Beach Resort just by Carlisle Bay.
(Michael Bourne)

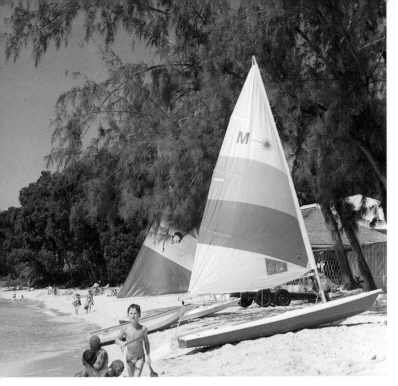

Paradise Beach
(G.W. Lennox)

The West Coast

The bays and beaches on this coast are lapped by the tranquil Caribbean Sea and offer delightful and safe bathing.

Heywoods Hotel near to Speightstown (left).
(G.W. Lennox)

The prestigious Sandy Lane Hotel (right). *(G.W. Lennox)*

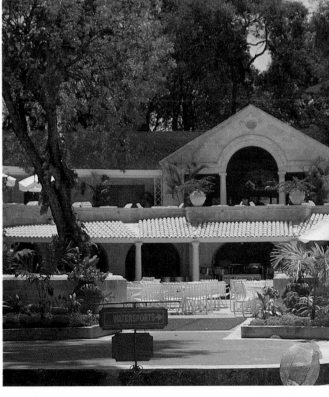

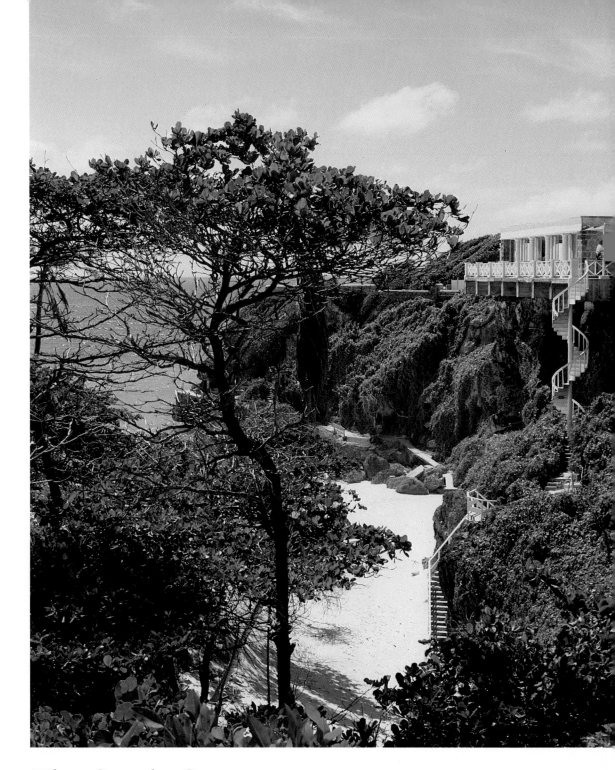

The South Coast

The sea off the south coast is affected by the trade winds so that the seas are less tranquil and the breakers can at times be heavy.

The beach at the Crane is one of the finest on this coast.

(G.W. Lennox)

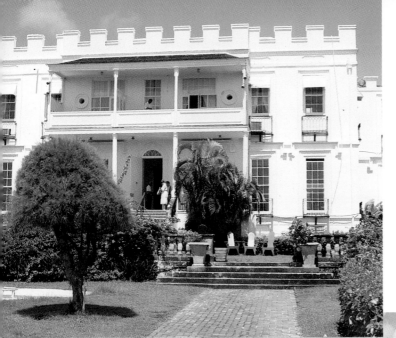

Sam Lord's Castle, an historic Georgian mansion, now part of a luxury resort hotel. The mansion was built by Sam Lord Hall, a famous buccaneer who lured ships to their doom on the rocks in the sea bordering the estate.
(G.W. Lennox)

Rockley Beach, one of the most popular with both Barbadians and visitors. The breakers are usually high enough for surfing whilst allowing safe bathing.
(G.W. Lennox)

Vendors displaying their wares at the 'beach shop'.
(G.W. Lennox)

7

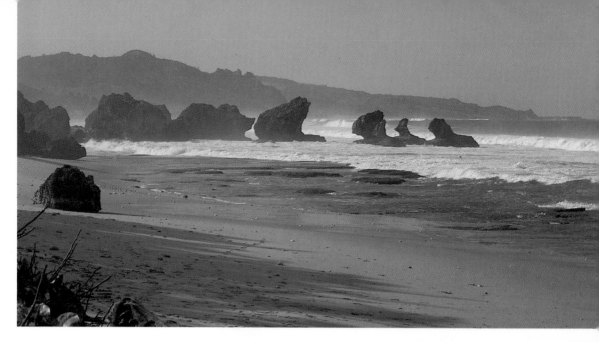

The East Coast

Coastline at Cattlewash
pounded by the breakers of
the Atlantic Ocean.
(G.W. Lennox)

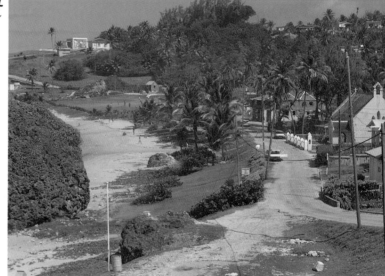

The fishing village at
Bathsheba. *(G.W. Lennox)*

Fishing boats at rest at
Bathsheba. *(G.W. Lennox)*

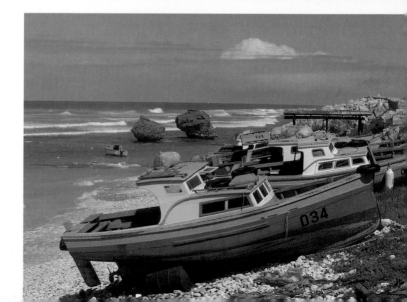

Great Houses

Great or Plantation houses are a reminder of the early prosperity from sugar.

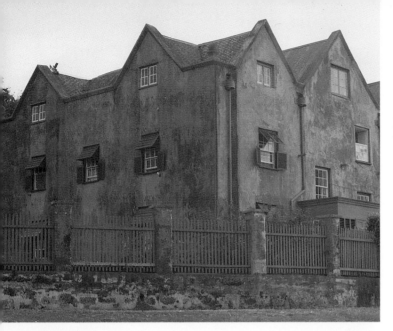

Drax Hall, famous for its early Jacobean staircase. *(G.W. Lennox)*

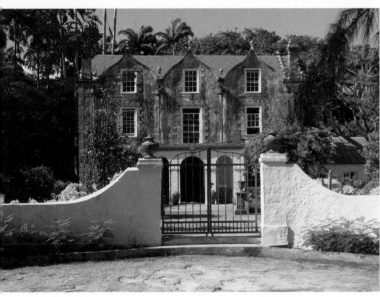

St. Nicholas Abbey, built around 1650, one of the two oldest houses in the English-speaking Western Hemisphere. *(Anne Bolt)*

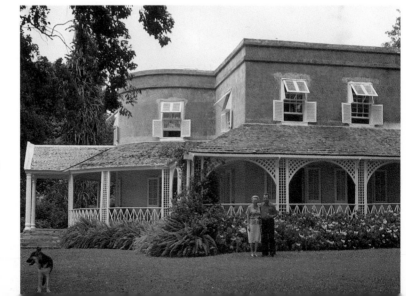

Villa Nova, once the Barbados home of Anthony Eden, a former British Prime Minister. *(G.W. Lennox)*

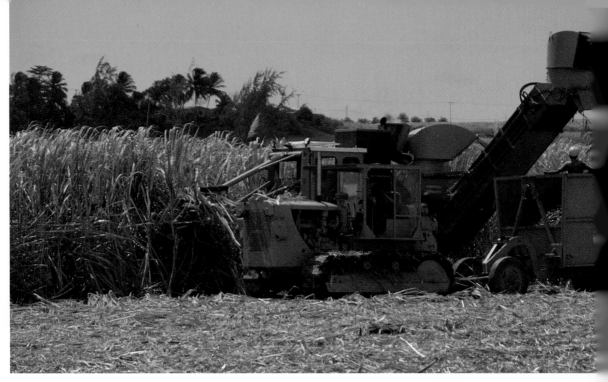

Most cane is now cut by sophisticated machinery. *(G.W. Lennox)*

Traditional hand-cutting is still carried out, especially on small or difficult parcels of land. *(G.W. Lennox)*

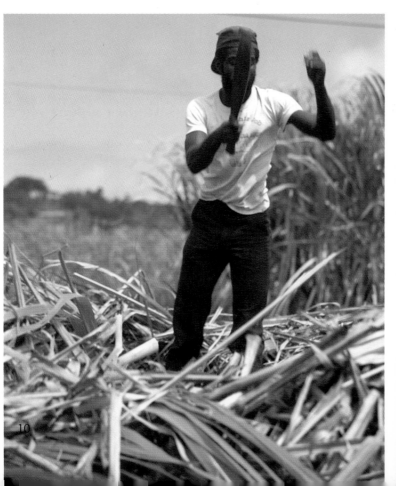

King Sugar

Inland the landscape is dominated by sugar-cane. Although Barbados is not now so dependent on the crop as in the past years, it is still an important part of the economy.

Sugar factory where the cane is crushed and processed.
(G.W. Lennox)

Wind-power was once used to grind sugar-cane. At one time there were over 500 windmills on the island.
The Morgan Lewis is the only windmill remaining with its sails intact. *(Michael Bourne)*

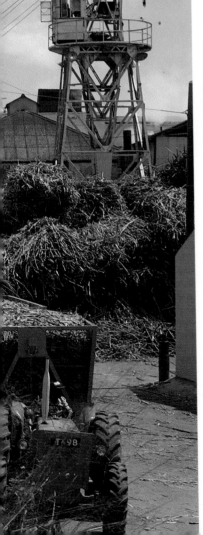

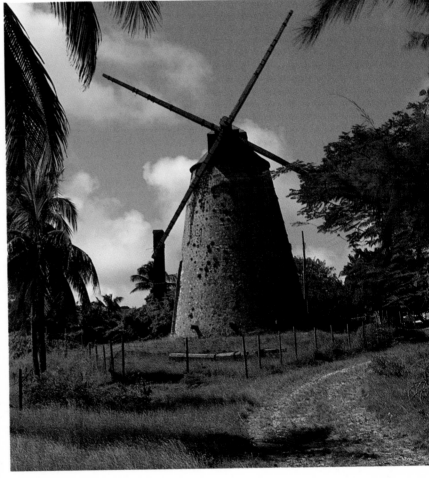

The Military Connection

There are a number of reminders of the British troops garrisoned on the island in past times.

Gun Hill Signal Station in St. George's, erected in 1818, which was used for communication with a number of similar stations over the island.
(G.W. Lennox)

The Lion Monument at Gun Hill. It was erected by the British garrison in 1868.
(G.W. Lennox)

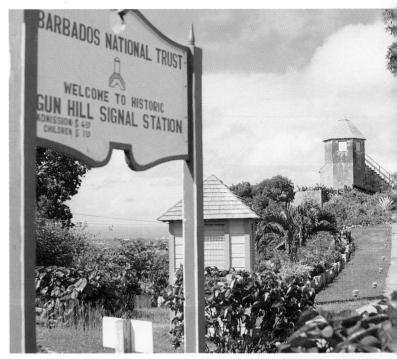

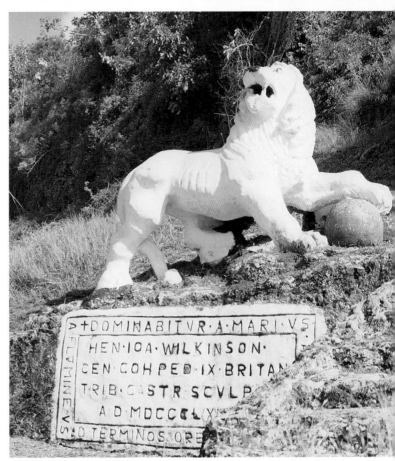

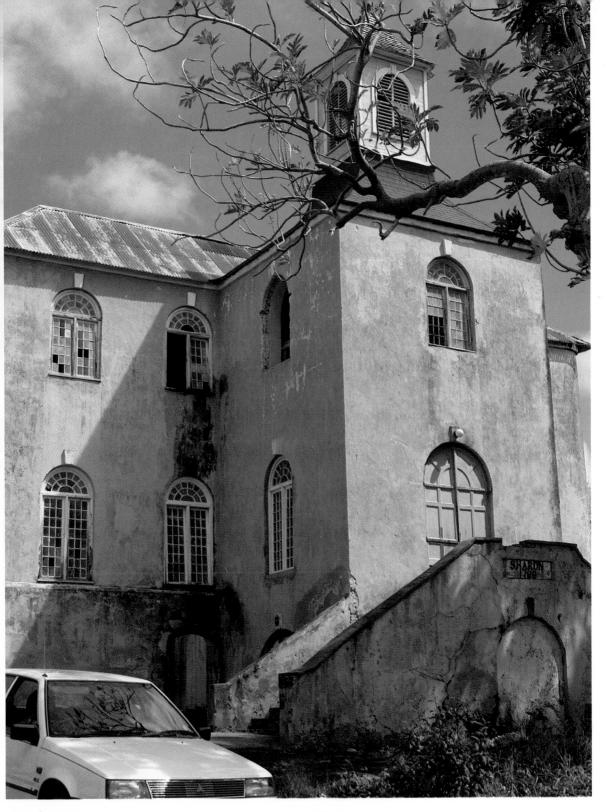

Sharon Moravian Church in St. Thomas, built in 1799. It is one of the few churches that permitted slaves to worship within its walls in the nineteenth century.

(G.W. Lennox)

Natural Life

Exotic flowers, trees and shrubs flourish all over the island.

Red blossom on the poinciana tree provides a vivid splash of colour (top left). *(Michael Bourne)*

This umbrella-shaped tree provides protection from both the tropical sun and the rain (top right). *(G.W. Lennox)*

Andromeda Gardens, situated high above the Atlantic coast. Open to the public, no lover of flowers should miss this 'Garden of Eden'. *(G.W. Lennox)*

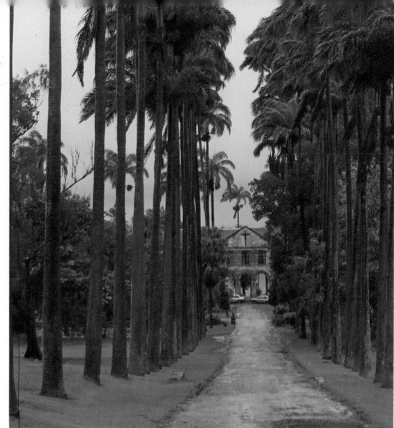

A fine row of cabbage palms at Codrington College. *(G.W. Lennox)*

Orchids. *(Michael Bourne)*

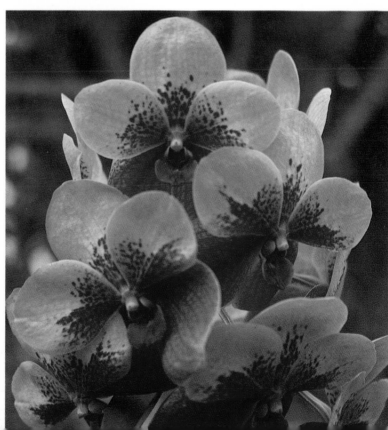

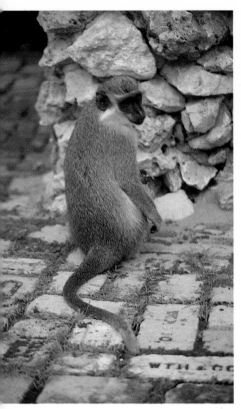

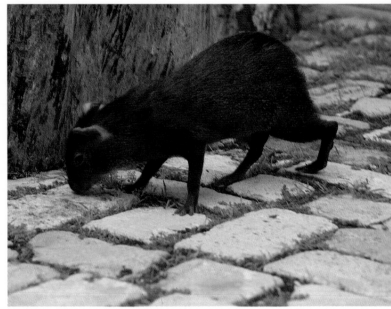

Wild Life

The Barbados green monkey can frequently be seen in quiet woodland areas of the island. *(G.W. Lennox)*

A jutia, native to Barbados, one of a collection of wild animals and birds in the Wildlife Park at Farley Hill. *(G.W. Lennox)*

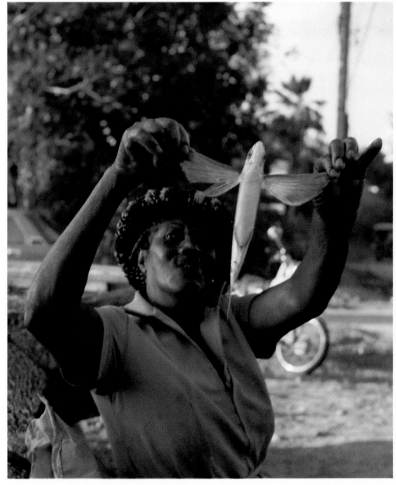

Flying fish are common in the seas around Barbados. The island's national dish is delicious whether grilled, deep fried or stewed. *(Anne Bolt)*

Natural Sights

Harrison's Cave, a series of underground caverns with waterfalls, stalagmites and stalactites illuminated by direct lighting. A tour by special train enables this spectacular sight to be enjoyed in safety.
(G.W. Lennox)

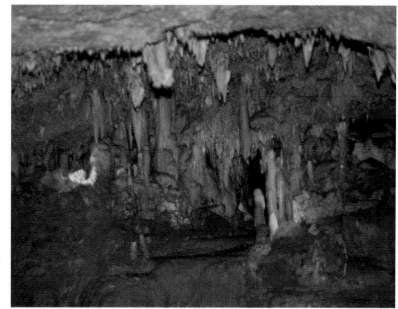

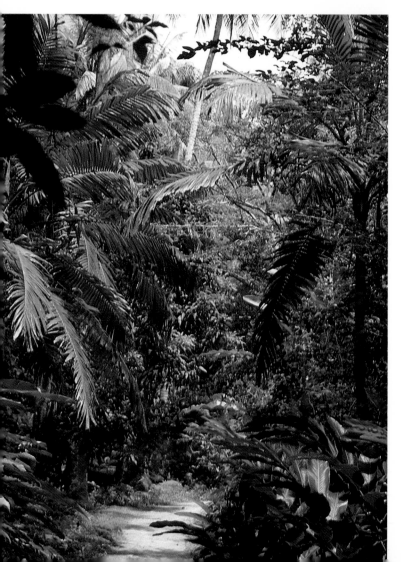

Welchman Hall Gulley, an unspoilt tropical garden situated in a ravine.
(G.W. Lennox)

19

Sport

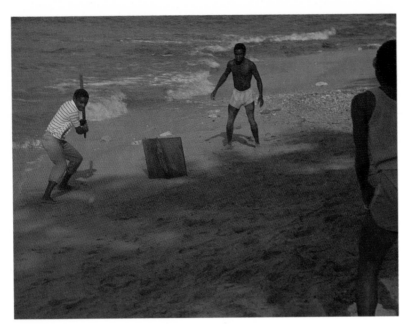

Cricket is Barbados' national game; it is played wherever a makeshift pitch can be found. *(Michael Owen)*

A cricket match at the Kensington Oval, the famous test match ground in Bridgetown. *(Anne Bolt)*

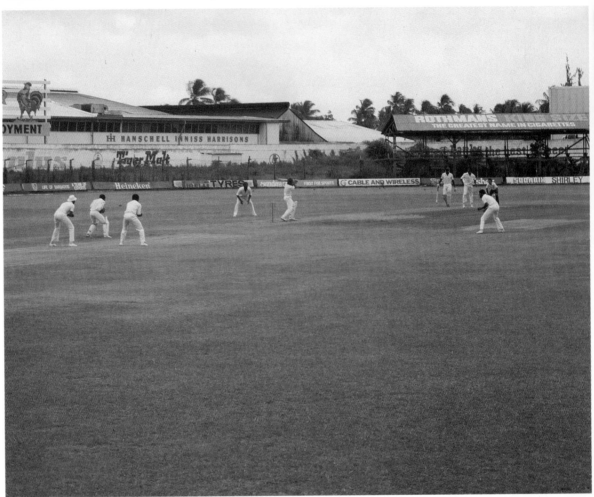

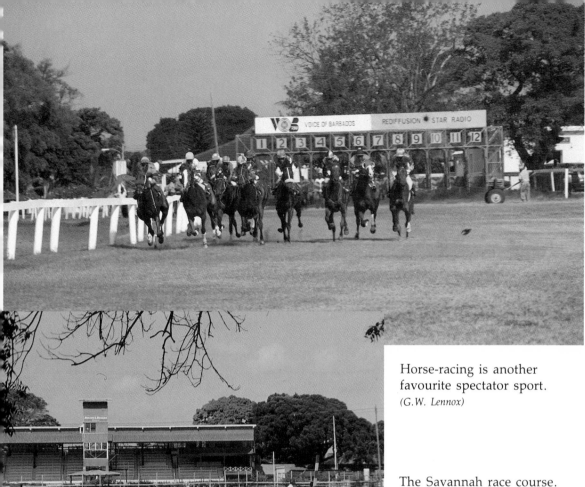

Horse-racing is another
favourite spectator sport.
(G.W. Lennox)

The Savannah race course.
(Michael Bourne)

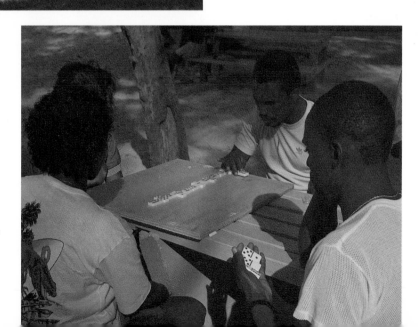

It only needs four Barbadian
men to get together for a
game of dominoes to start up.
(Michael Owen)

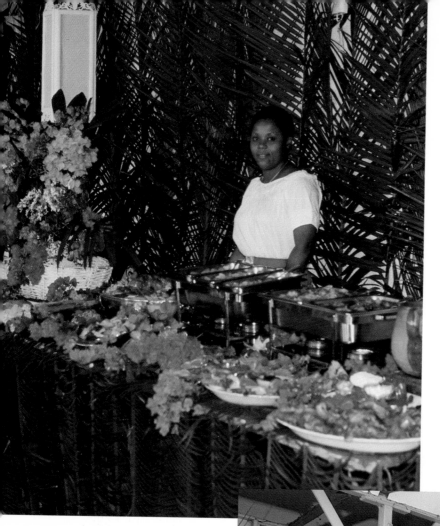

Sunday lunchtime buffet is a feast enjoyed by both Barbadians and visitors. *(G.W. Lennox)*

Eating Out

A rum shop, one of many found all over the island where Barbados' own drink can be enjoyed in its many varieties. *(Henshall Innes)*

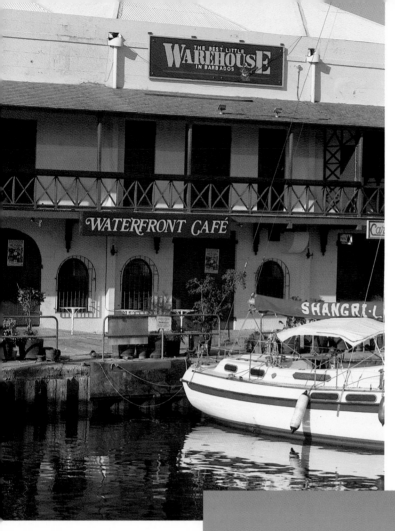

The Waterfront Restaurant by the Careenage is the ideal spot for the refreshing drink or meal either at lunch time or in the evening. *(G.W. Lennox)*

The Ship Inn at St. Lawrence Gap, noted for its good food and for being one of the liveliest nightspots. *(G.W. Lennox)*

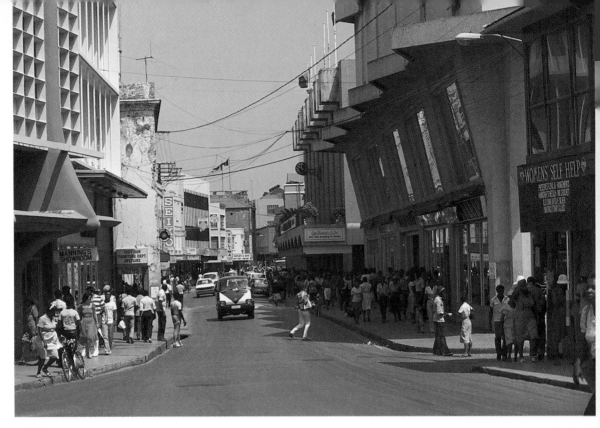

Shopping

Busy Broad Street in the centre of Bridgetown contains stores with a variety of luxury goods from all over the world.
(Michael Bourne)

The Best of Barbados shops sell a wide selection of products by local artists, craftsmen, potters and writers.
(Jimmy Walker)

Inside a leading department store offering duty free shopping to visitors.
(G.W. Lennox)

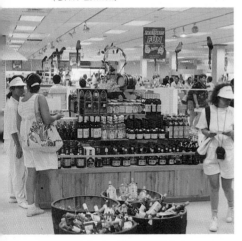

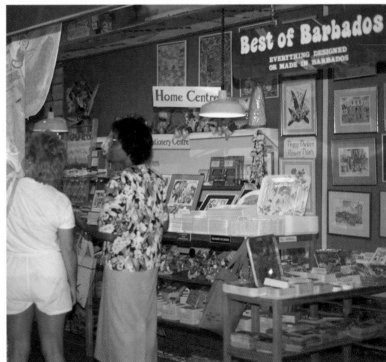

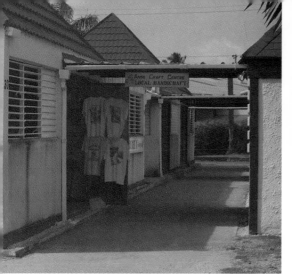

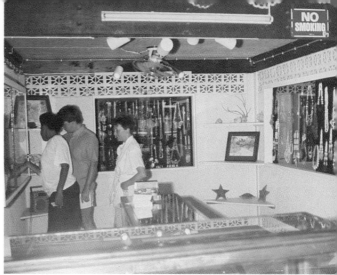

Local Craft

Pelican Village, an arts and
craft centre near the harbour
where a variety of work by
Barbadian craftsmen can be
purchased. *(Michael Owen)*

A potter working at his
outside kiln in the hills at
Chalky Mount. *(Willie Alleyne)*

25

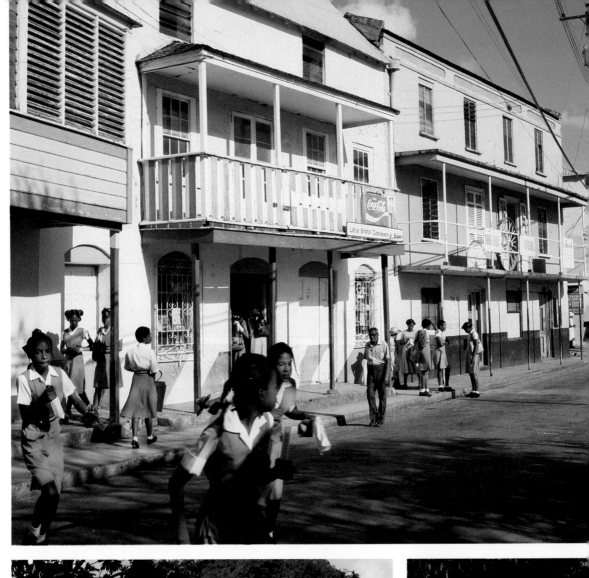

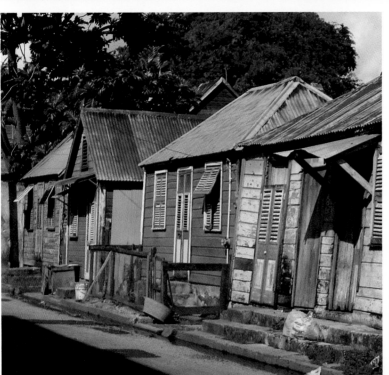

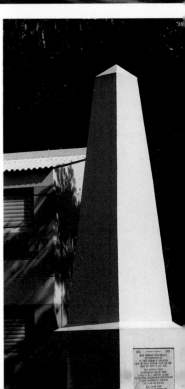

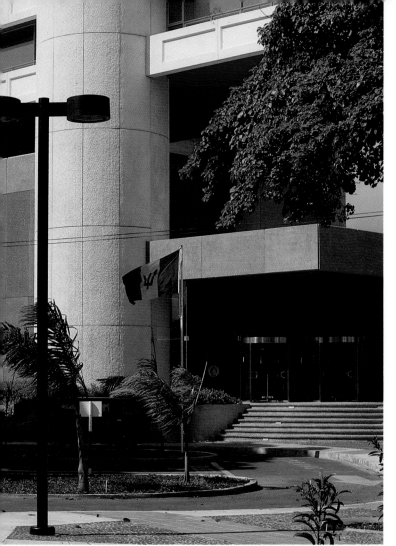

New Barbados

The Barbados Central Bank building. *(G.W. Lennox)*

The regional headquarters of Cable and Wireless.
(G.W. Lennox)

Old Barbados

A row of old buildings in Speightstown (top far left). *(Anne Bolt)*

Chattel houses, the traditional Barbadian style of house, built of wood and frequently on a base of loose stones making the house easy to dismantle and move (below far left). *(G.W. Lennox)*

The monument at Holetown commemorating the landing of the first Englishman in 1627 (below left). *(G.W. Lennox)*

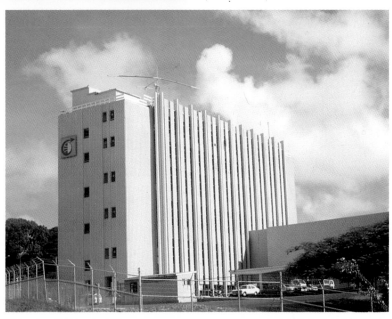

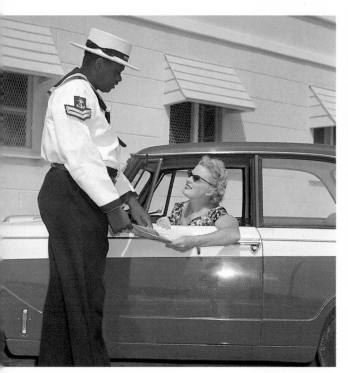

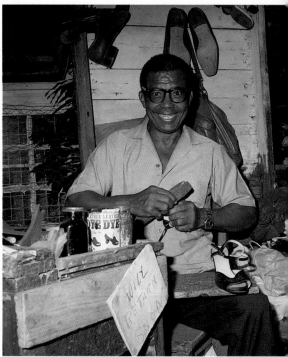

People of Barbados

A member of the Harbour Police who still wear their traditional uniforms. *(Anne Bolt)*

The local shoemaker. *(Anne Bolt)*

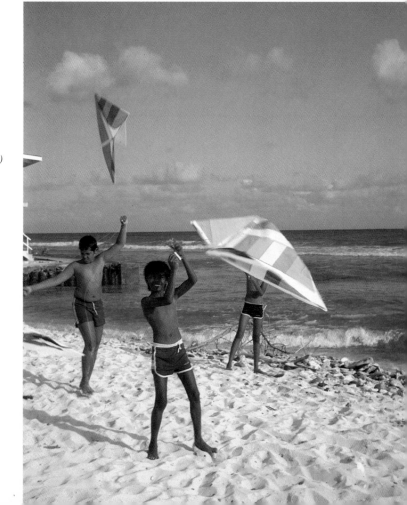

Kite flying is a popular pastime with young children, the fresh sea breezes keeping the kites aloft. *(G.W. Lennox)*

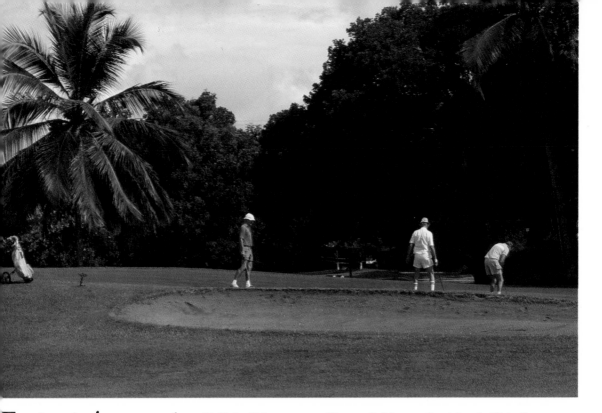

Entertainment by Day

Golf facilities are readily available on the island. This fine 18-hole course is at Sandy Lane on the west coast. *(G.W. Lennox)*

The Royal Barbados Police band entertaining the crowd at one of its regular performances at Hastings Rocks. *(G.W. Lennox)*

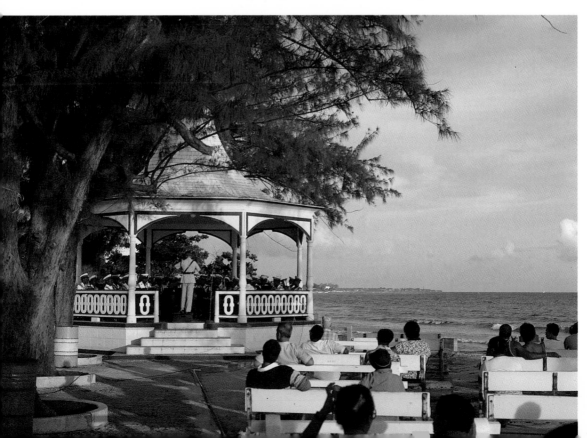

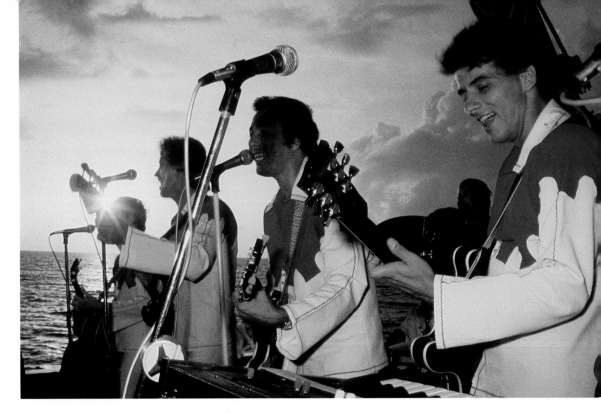

Entertainment by Night

The Merrymen, for many years the most popular group for both listening and dancing to. *(Mrs J. Straker)*

Spice, Barbados' top reggae pop group. *(Mrs J. Straker)*

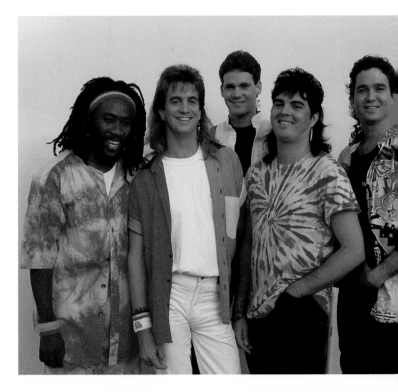

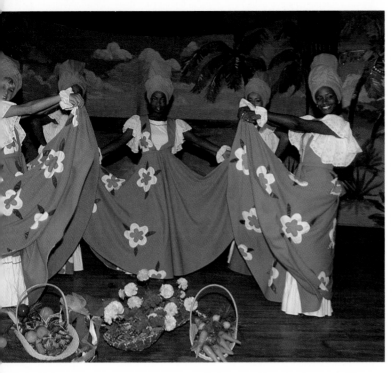

Plantation Tropical Spectacular, a twice weekly show of song, dance, music and folklore. *(F.A. Hoyos)*

Limbo dancer, a popular entertainment with visitors in the island's nightspots. *(Michael Owen)*

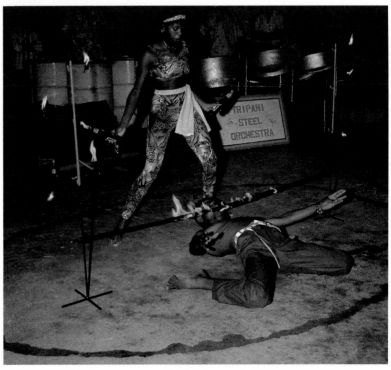

The sun sets on another
perfect Barbados day.
(G.W. Lennox)

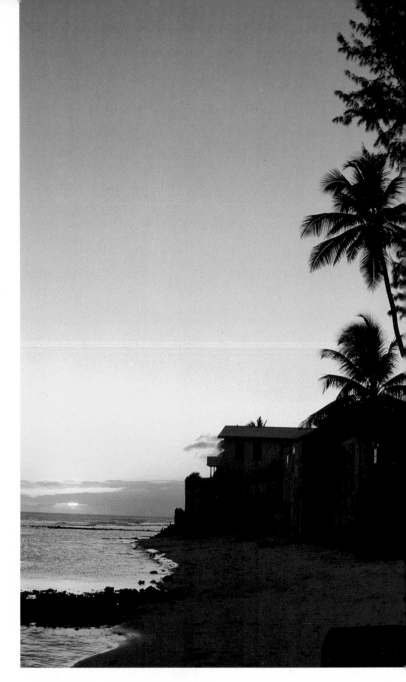

First published 1989

Published by *Macmillan Publishers Ltd*
London and Basingstoke
Associated companies and representatives in Accra,
Auckland, Delhi, Dublin, Gaborone, Hamburg, Harare,
Hong Kong, Kuala Lumpur, Lagos, Manzini, Melbourne,
Mexico City, Nairobi, New York, Singapore, Tokyo

Printed in Hong Kong

ISBN 0–333–49125–4

A CIP catalogue record for this book is available
from the British Library

Acknowledgements
Cover photographs are courtesy of G.W. Lennox, and show the House of
Assembly, the Morgan Lewis Windmill, Paradise Beach, and sugar-cane
being harvested.